My Doodle Book

Treasures Beyond Measure

http://TreasuresBeyondMeasure.com

My Doodle Book

Keep all your doodles in one place - right here in this doodle book! This doodle book lets you express yourself with your own art - draw big, draw small, draw tame, draw wild - it's all your own creation! Most of all, have fun...

Let's go!

If you've filled this book, you can get another one from Amazon:
http://KensBestPicks.com/doodle-book

www.ingramcontent.com/pod-product-compliance
Lightning Source LLC
Chambersburg PA
CBHW081608170526
45166CB00009B/2881